Beautiful Lingerie Model Pictures

By **ALEX WILLS**

Copyright © The Exotics

All rights reserved. No part of this document may be
Reproduced or transmitted in any form or by any means, electronic, mechanical, photocopying,
Recording, or otherwise, without prior written permission of Alex Wills.

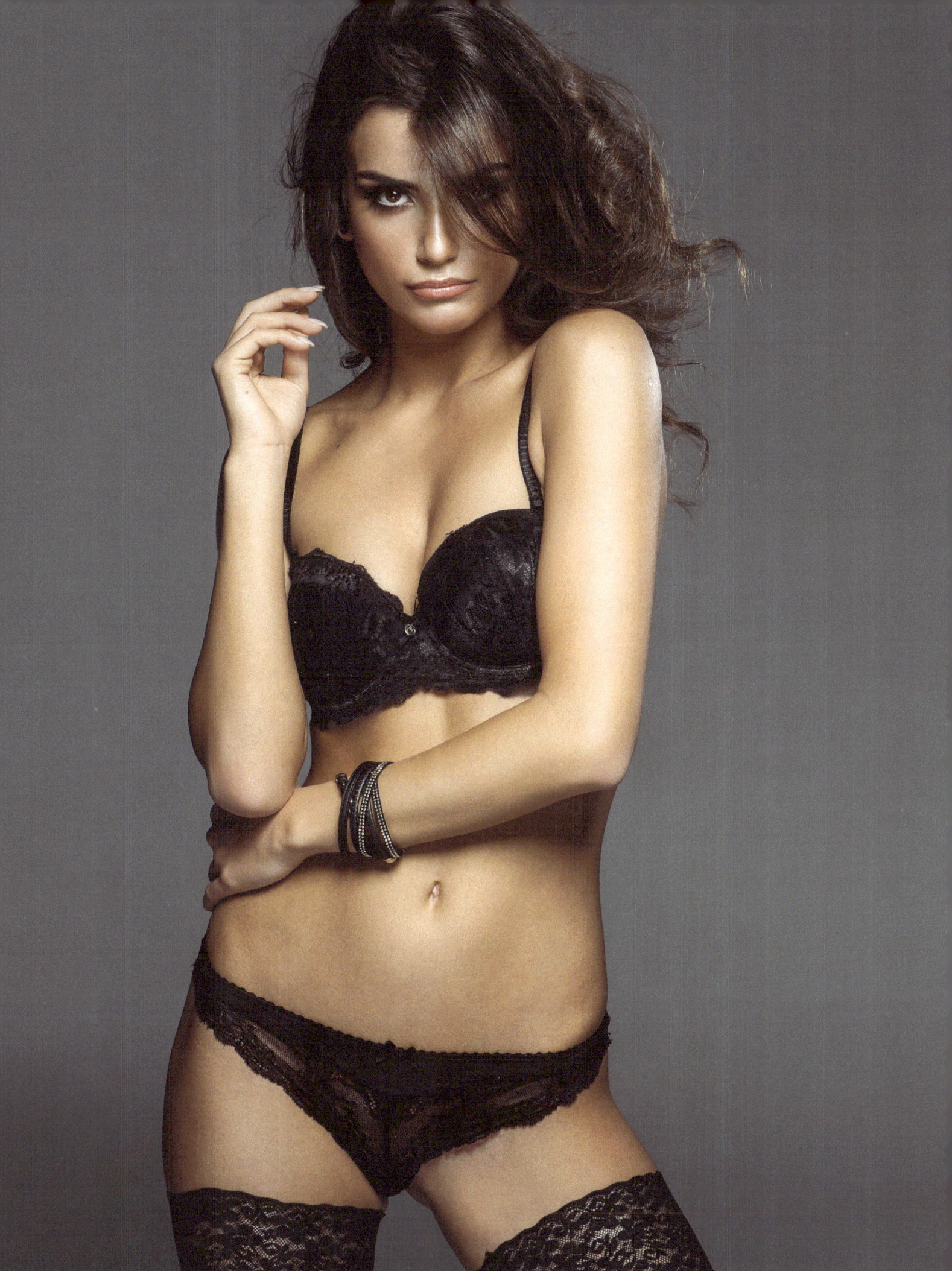

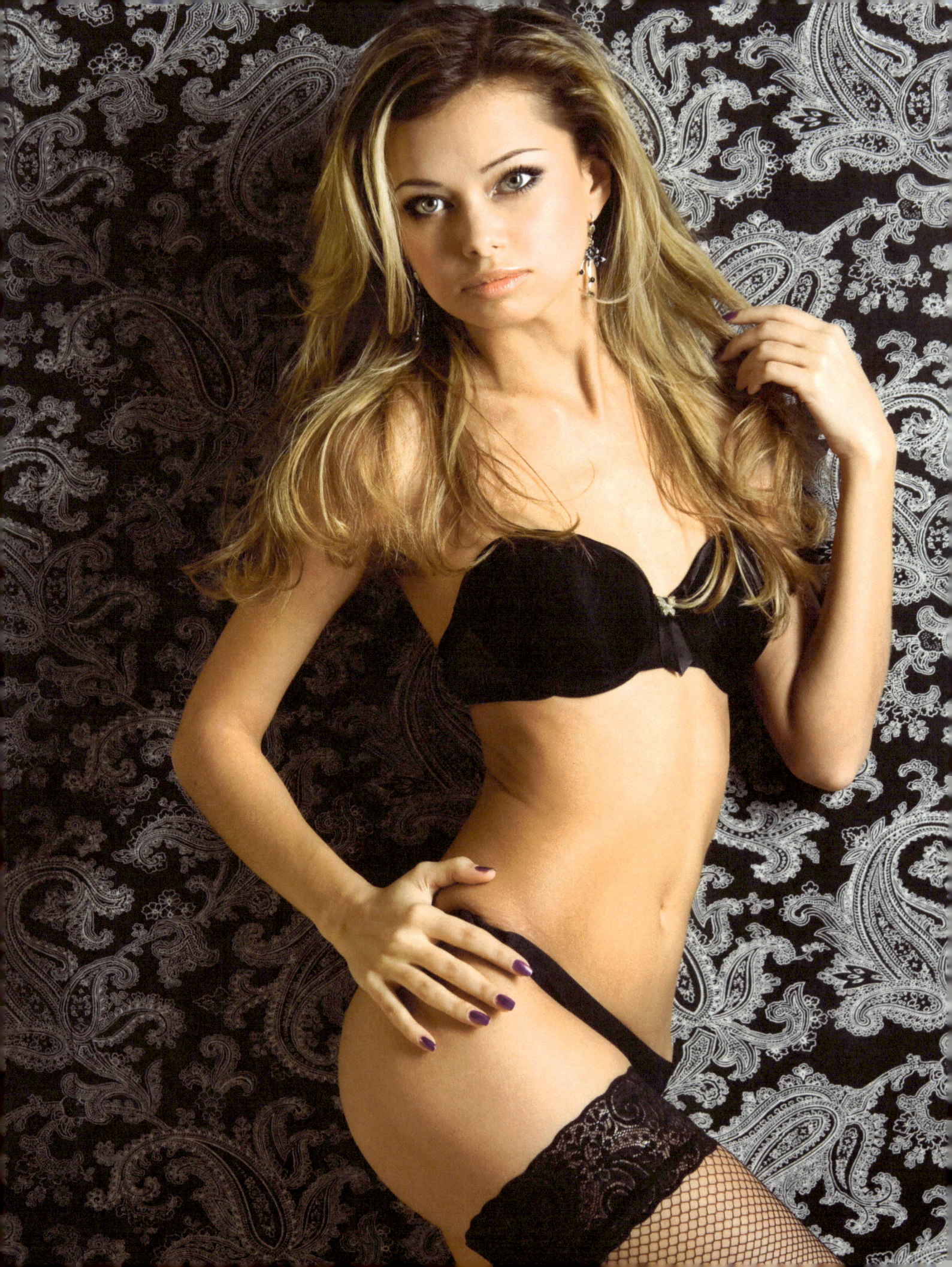

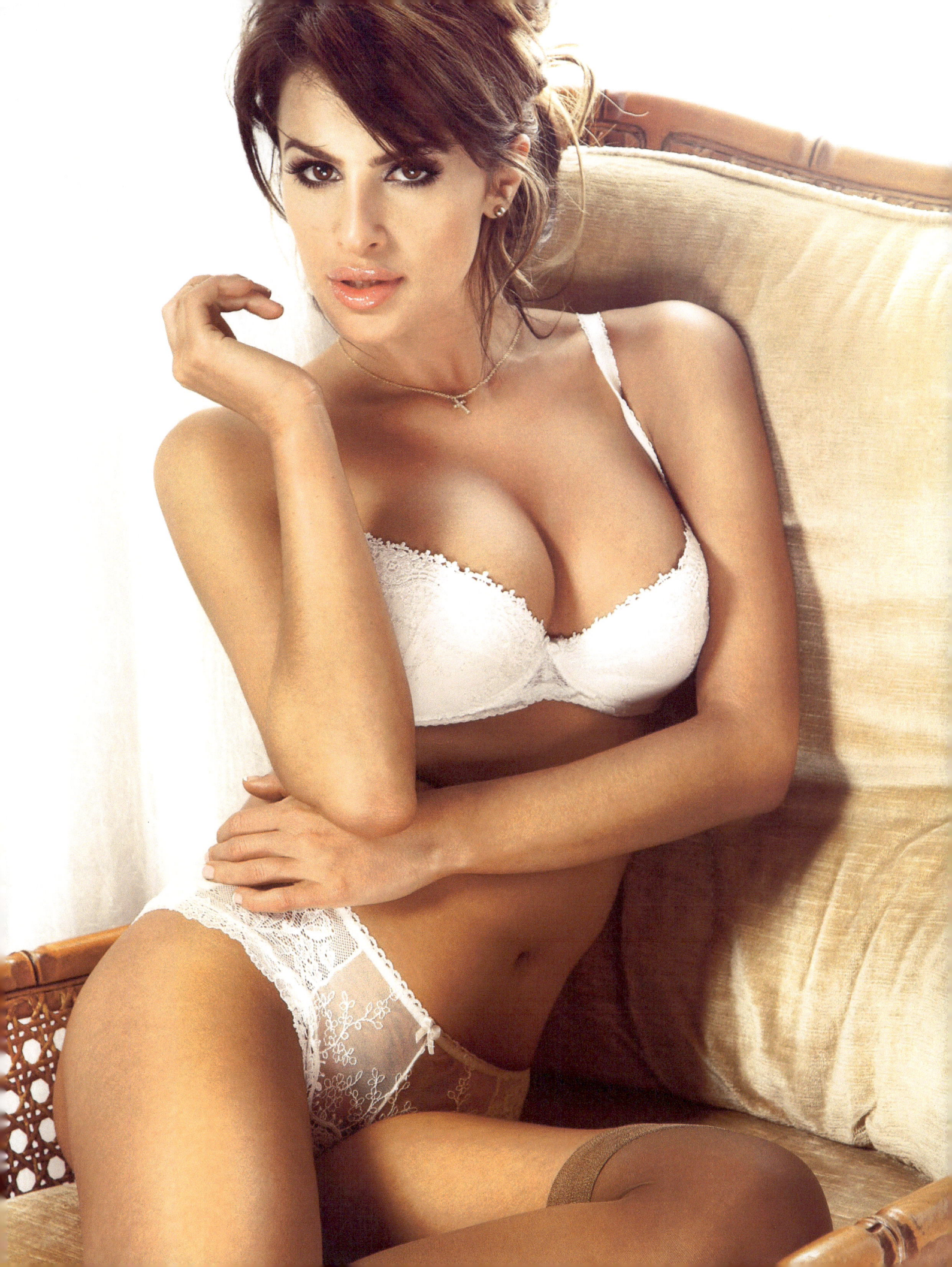

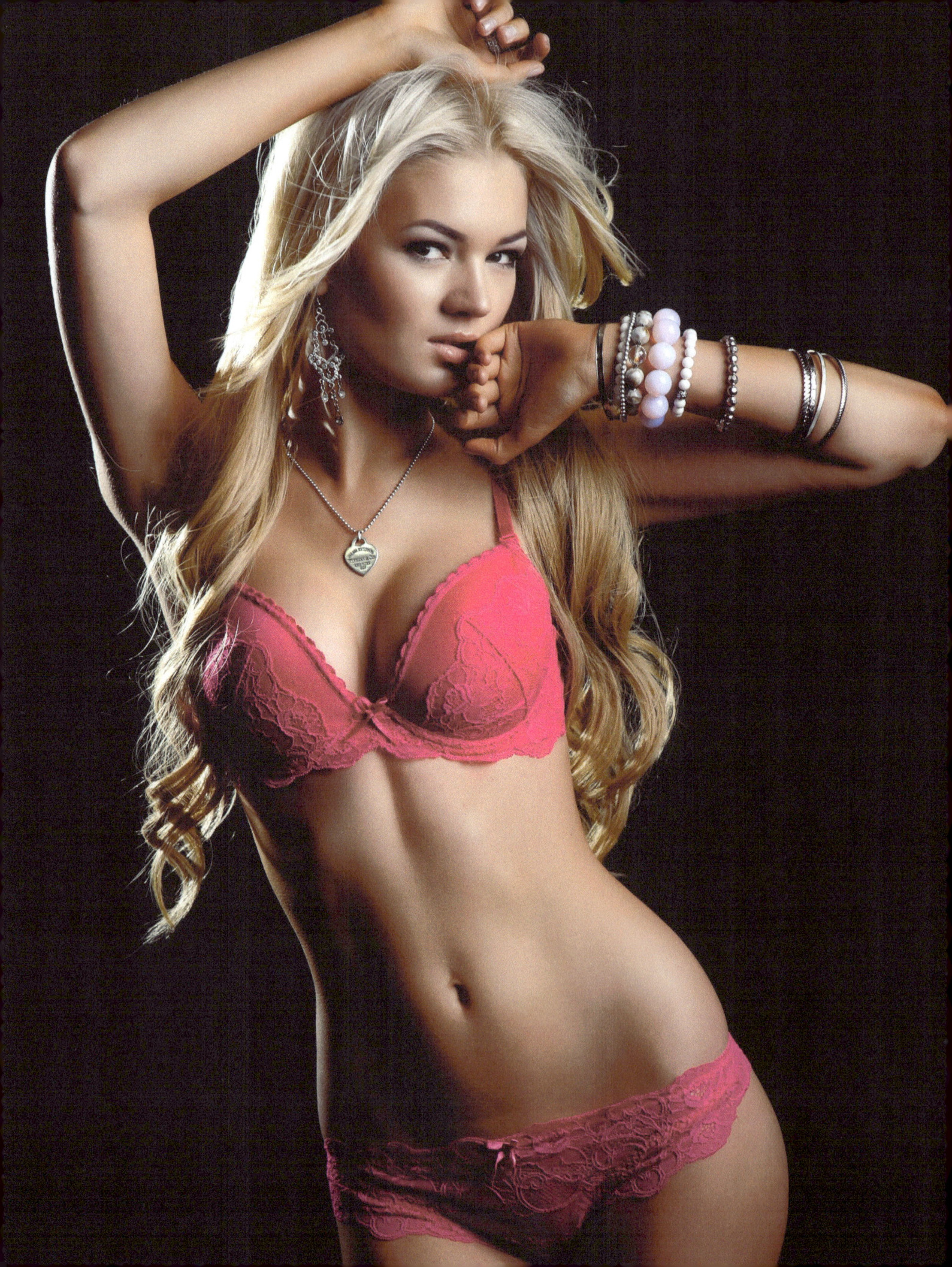

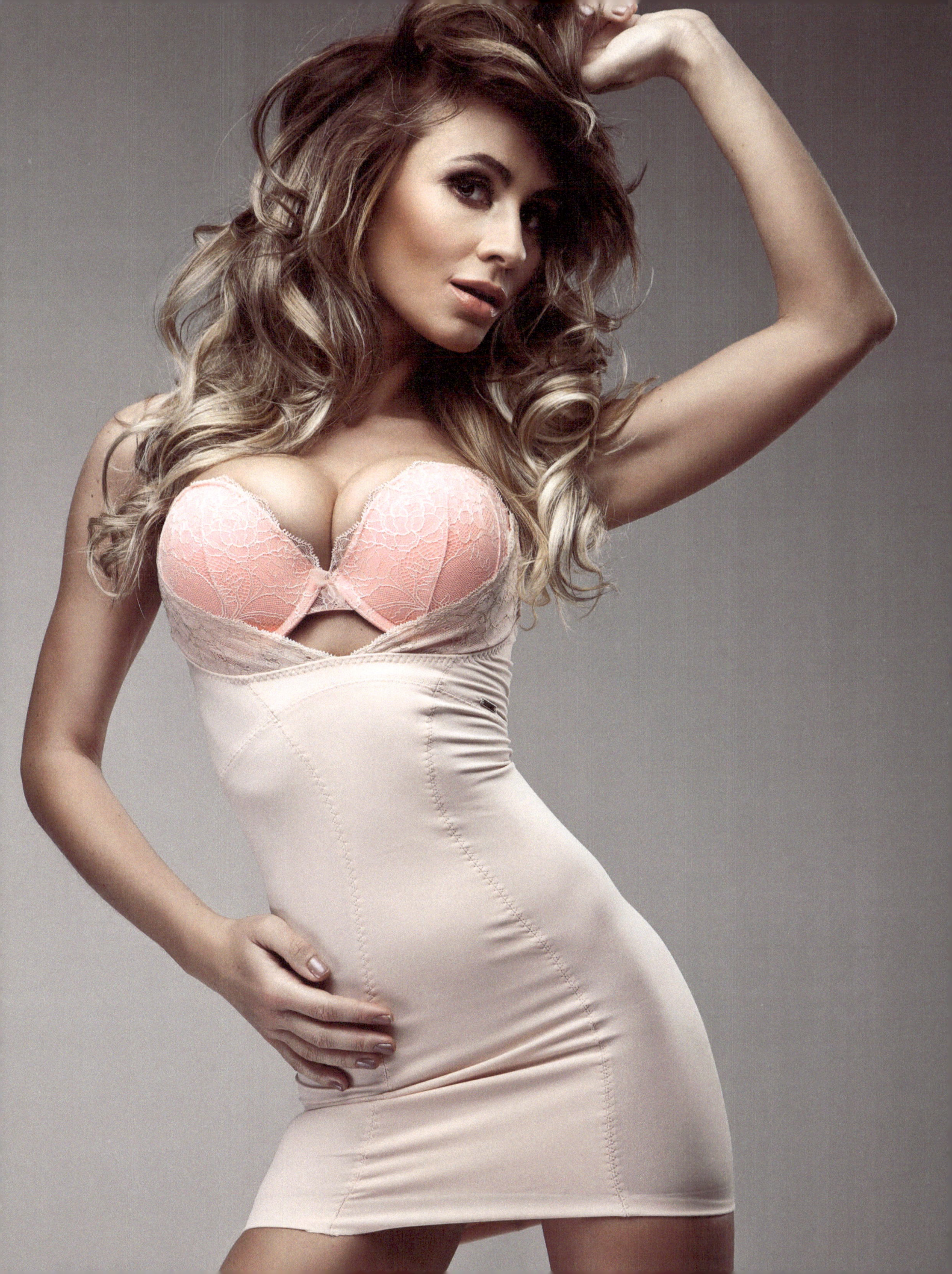

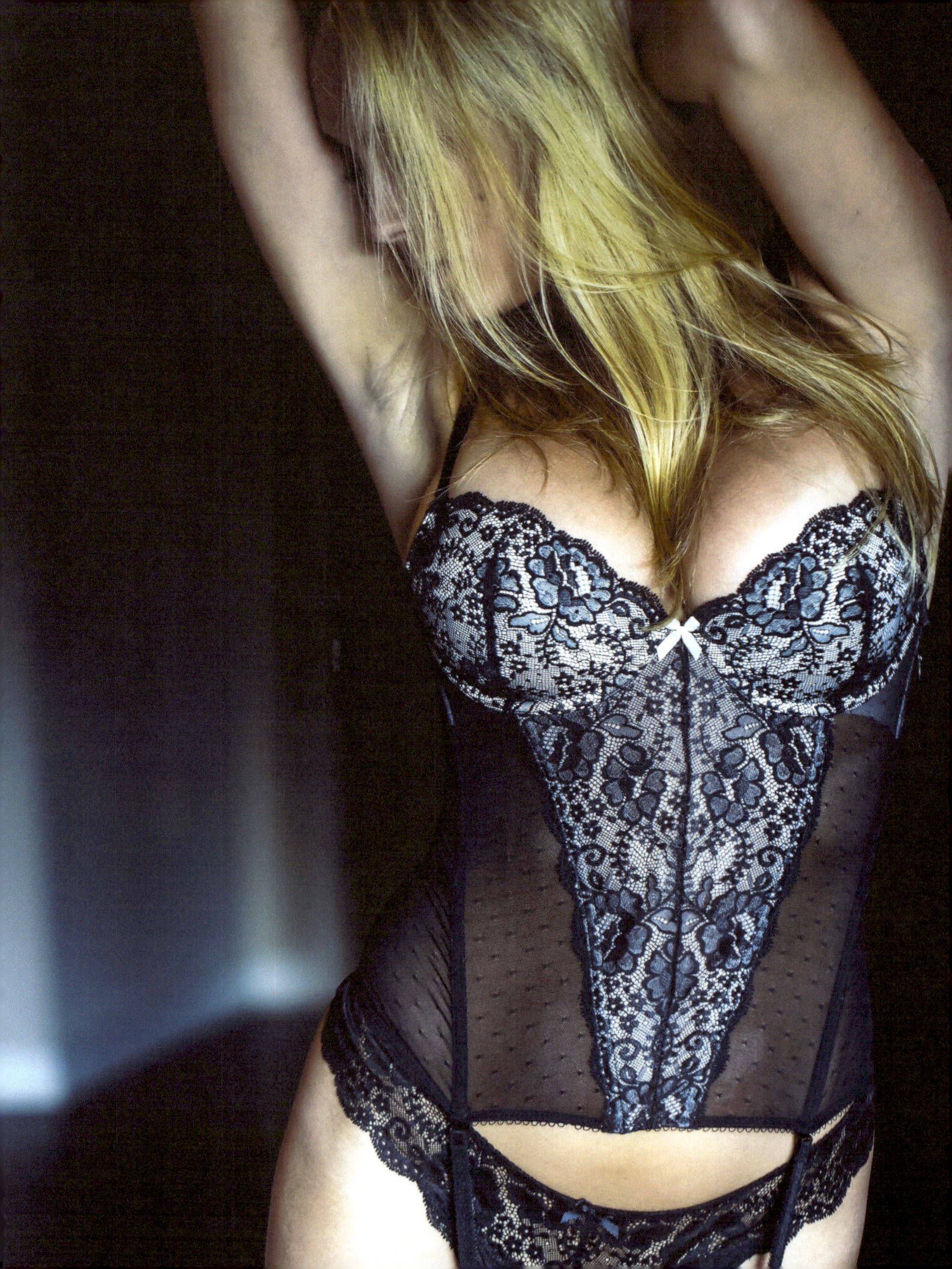

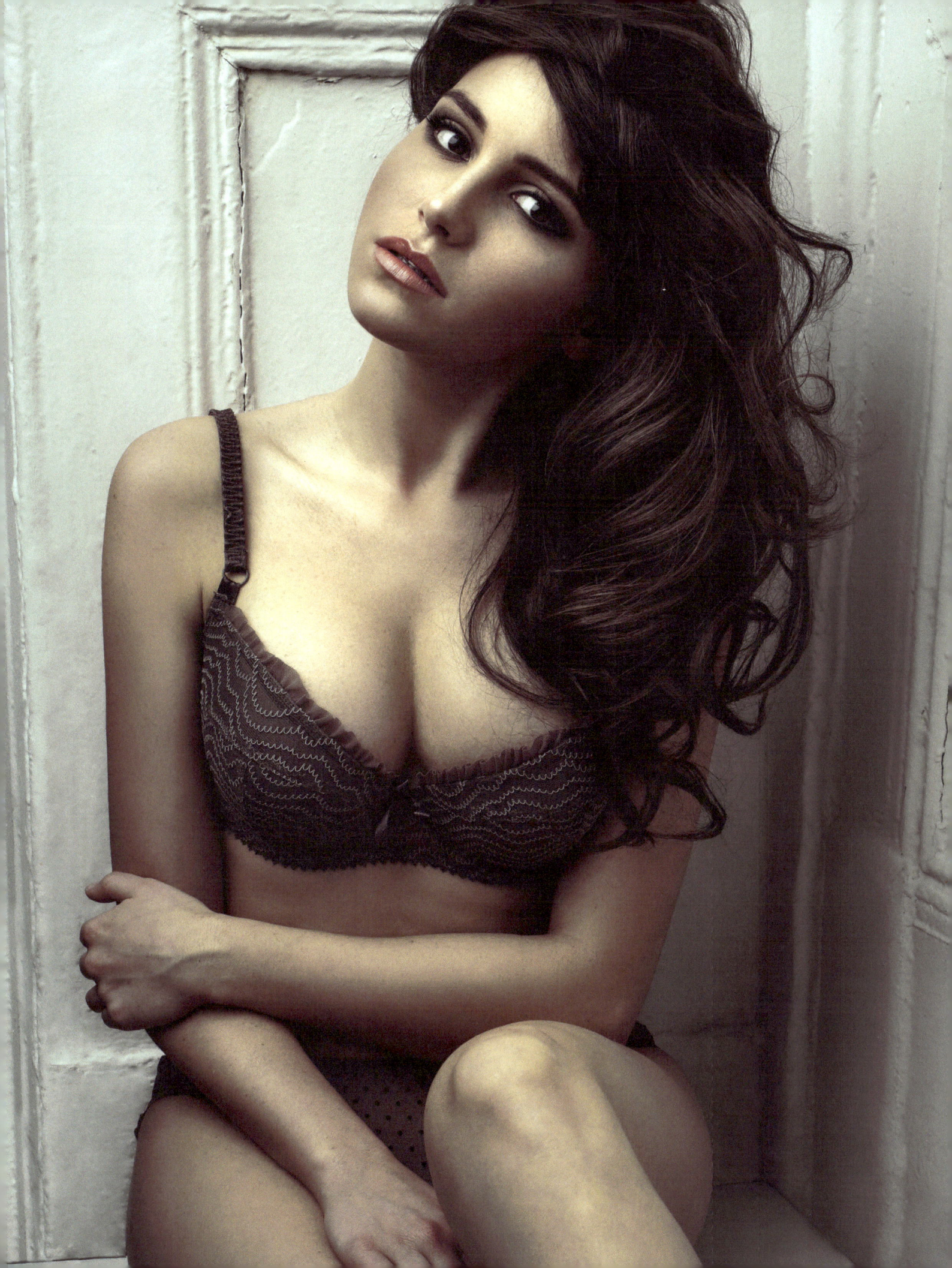

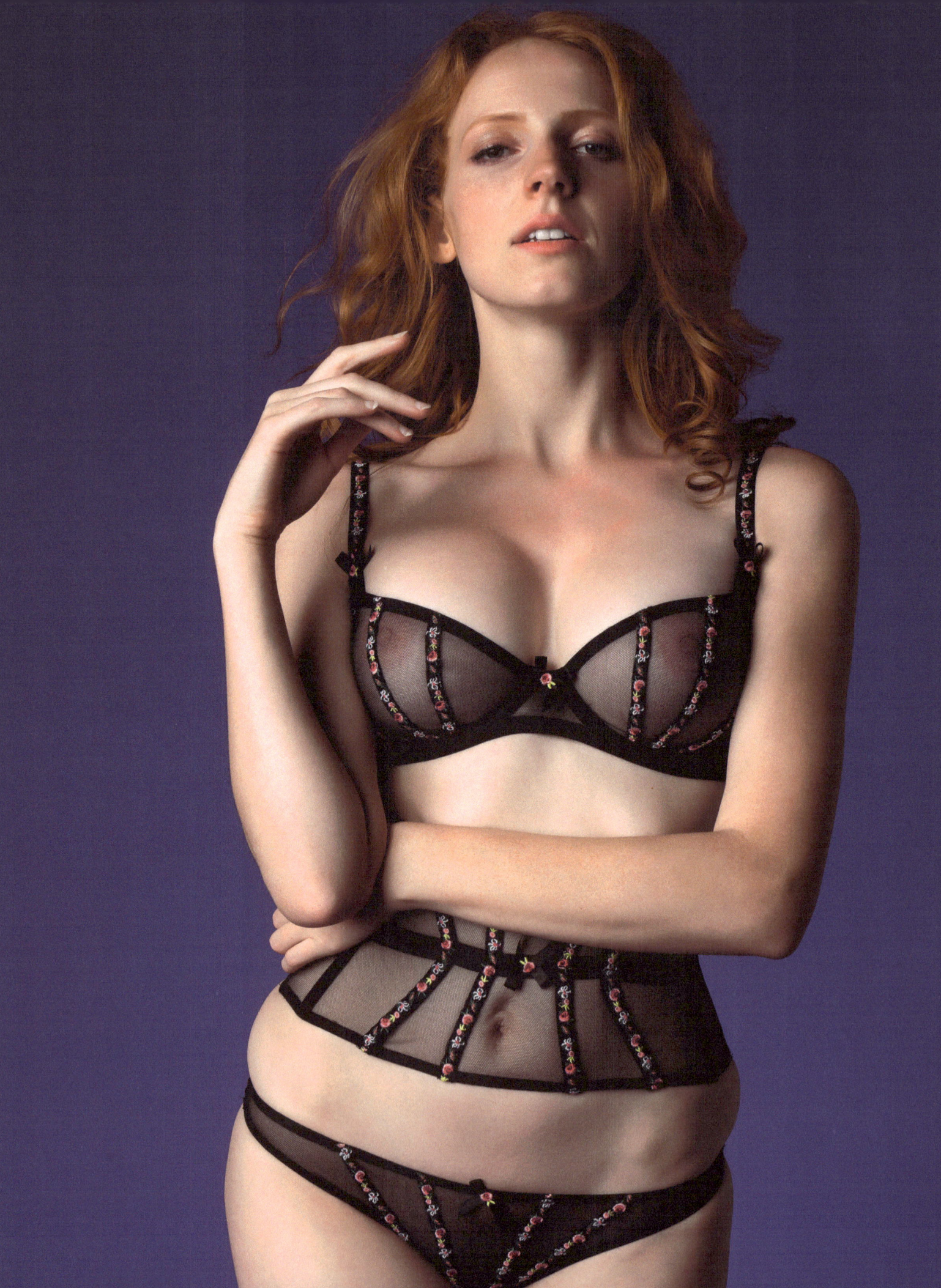

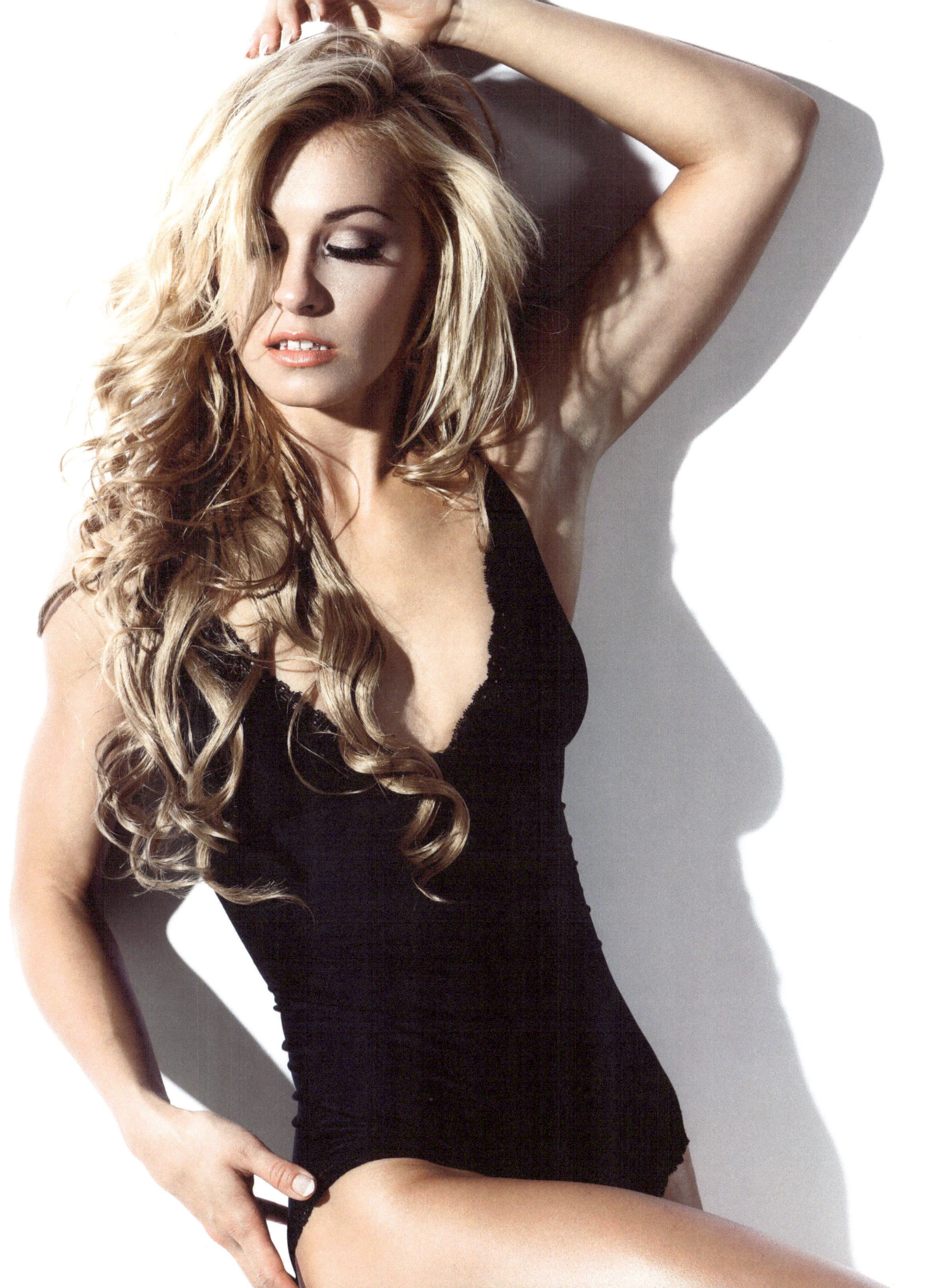

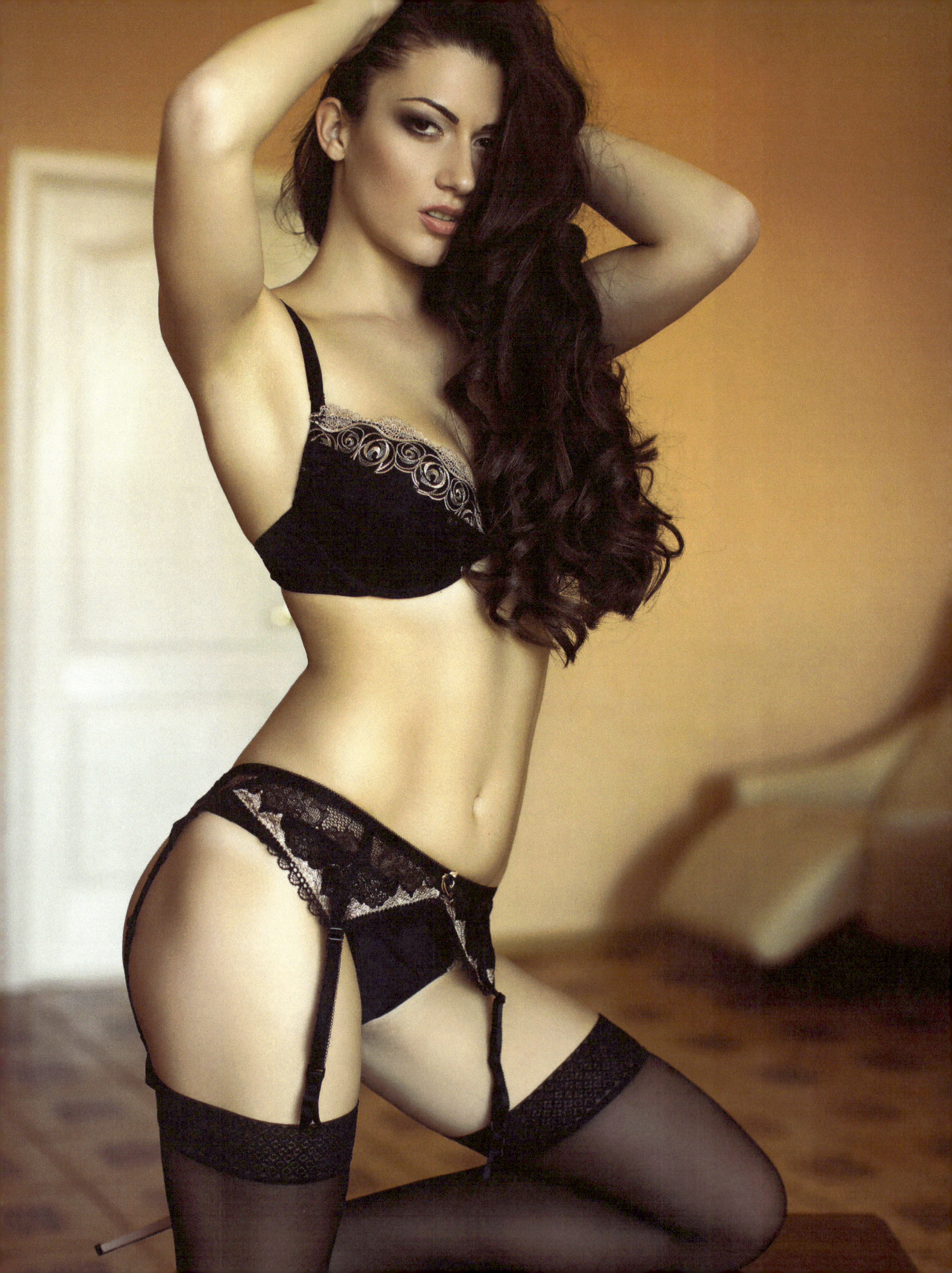

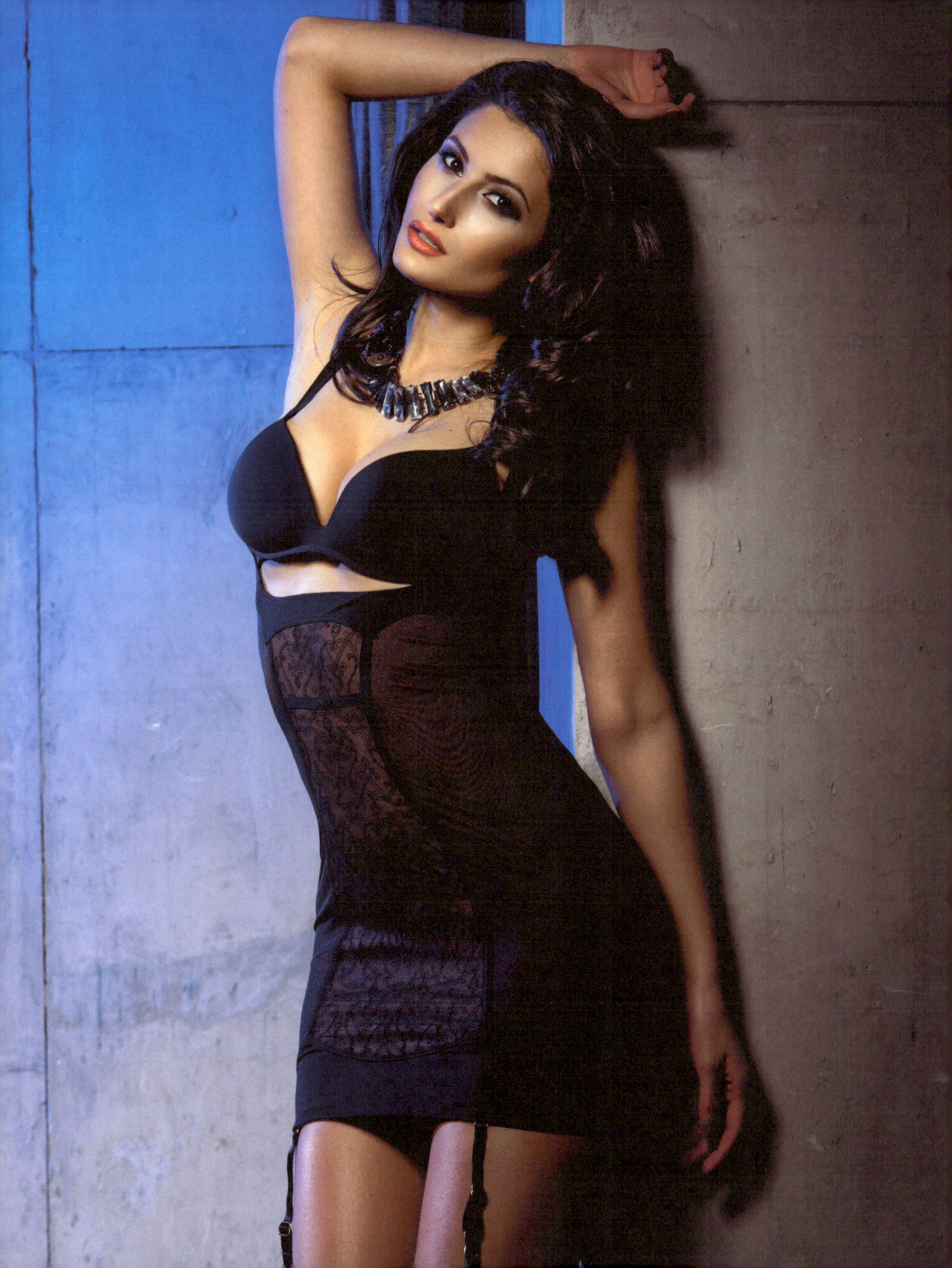

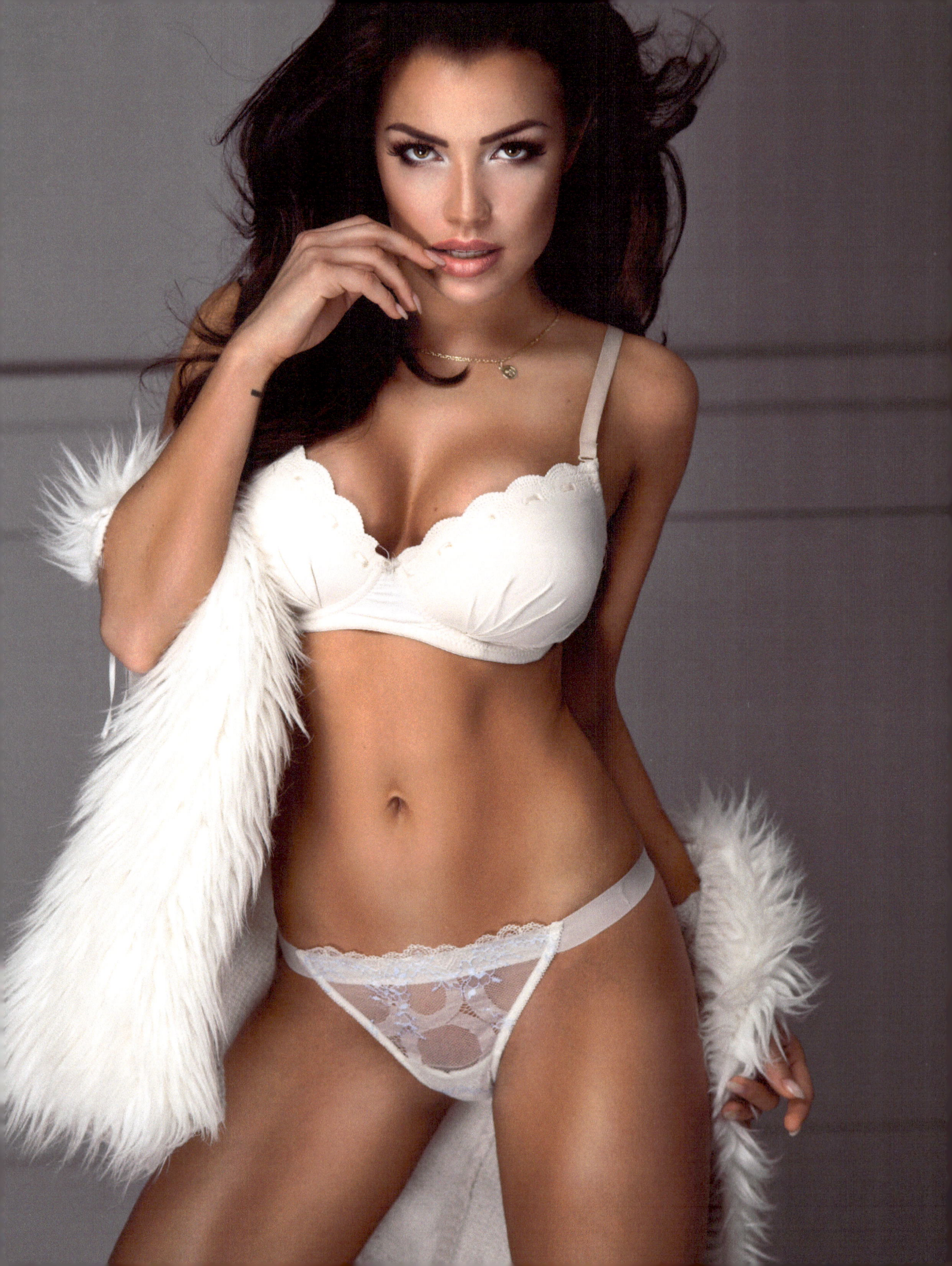

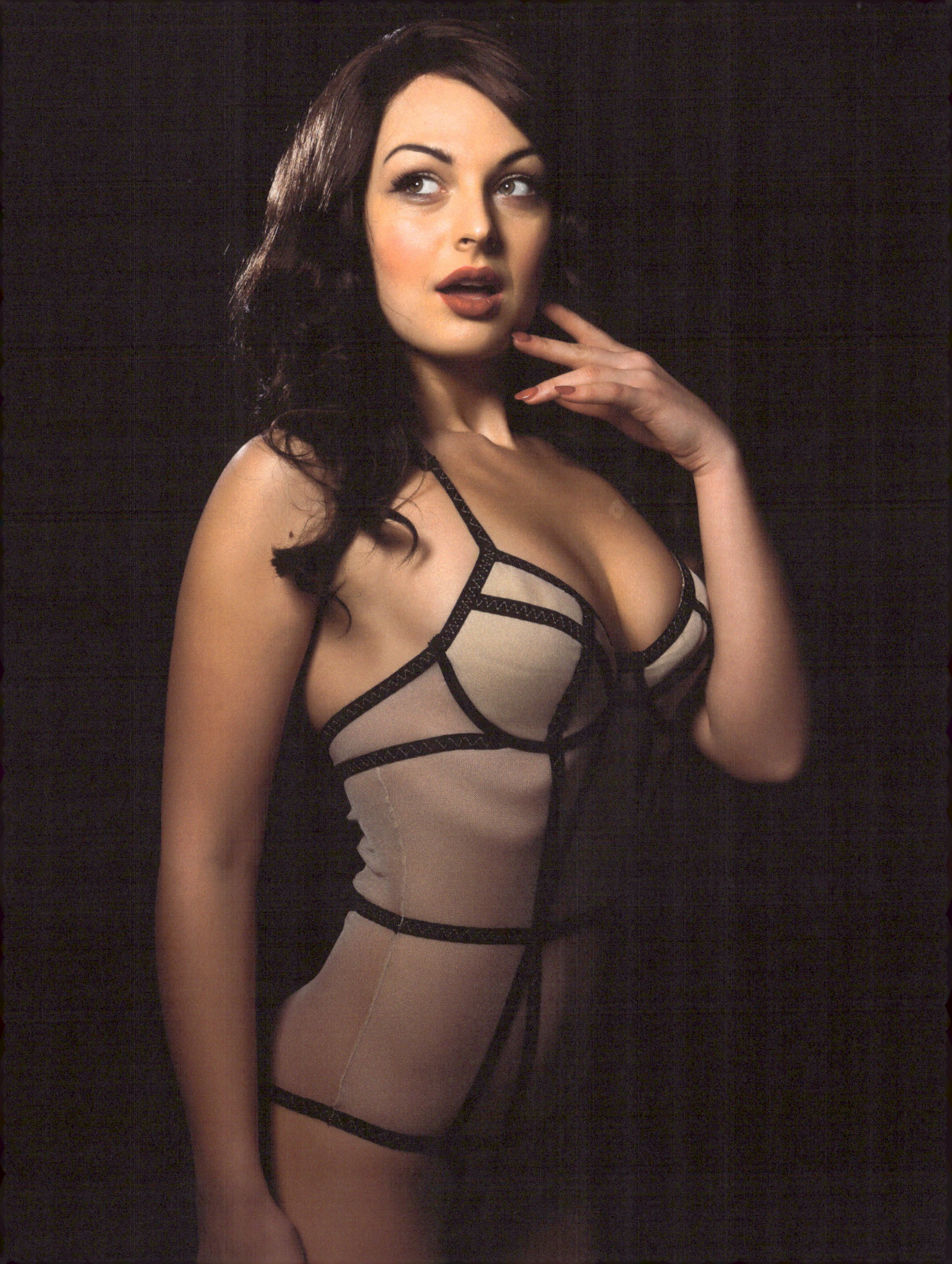

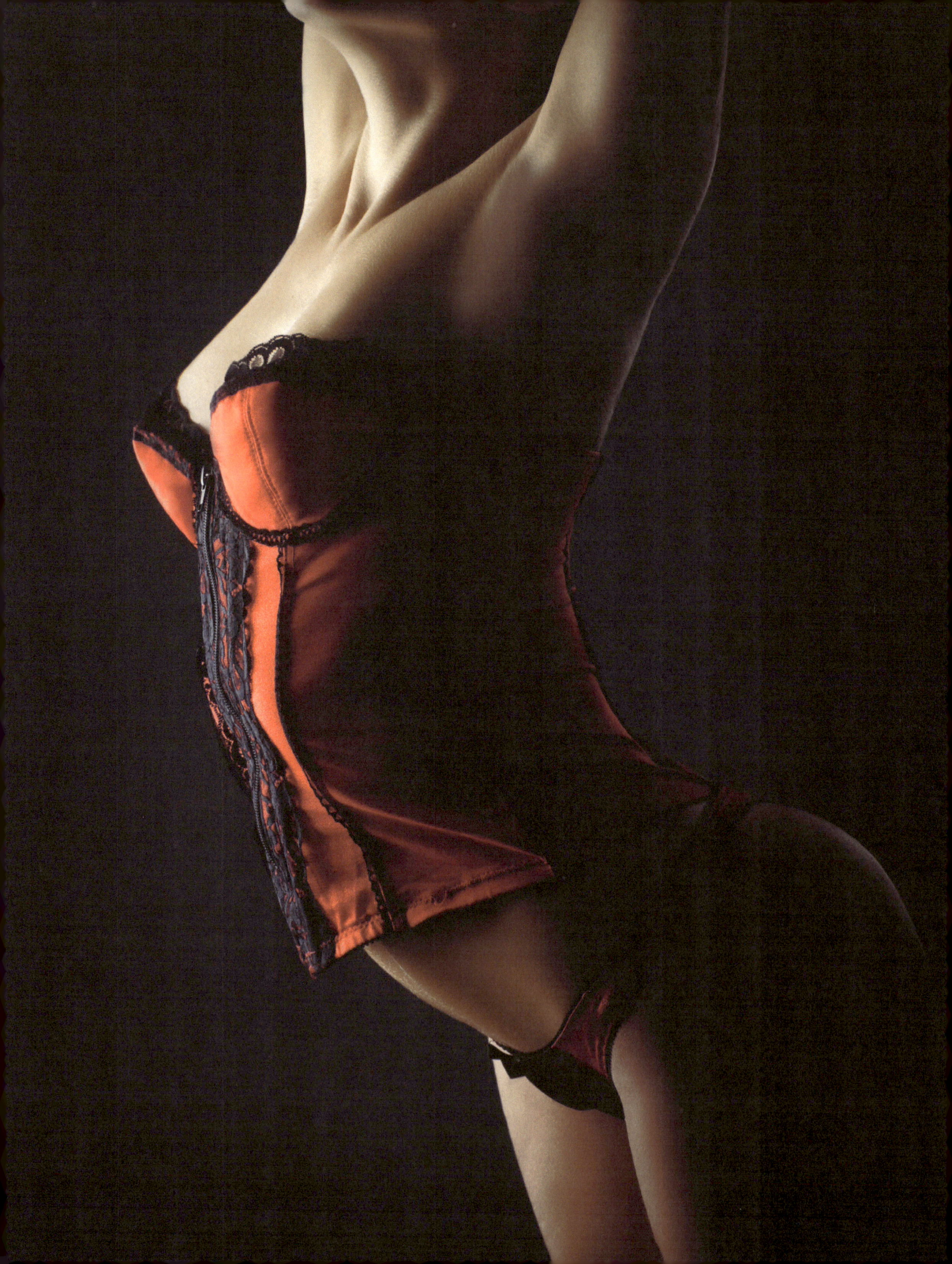

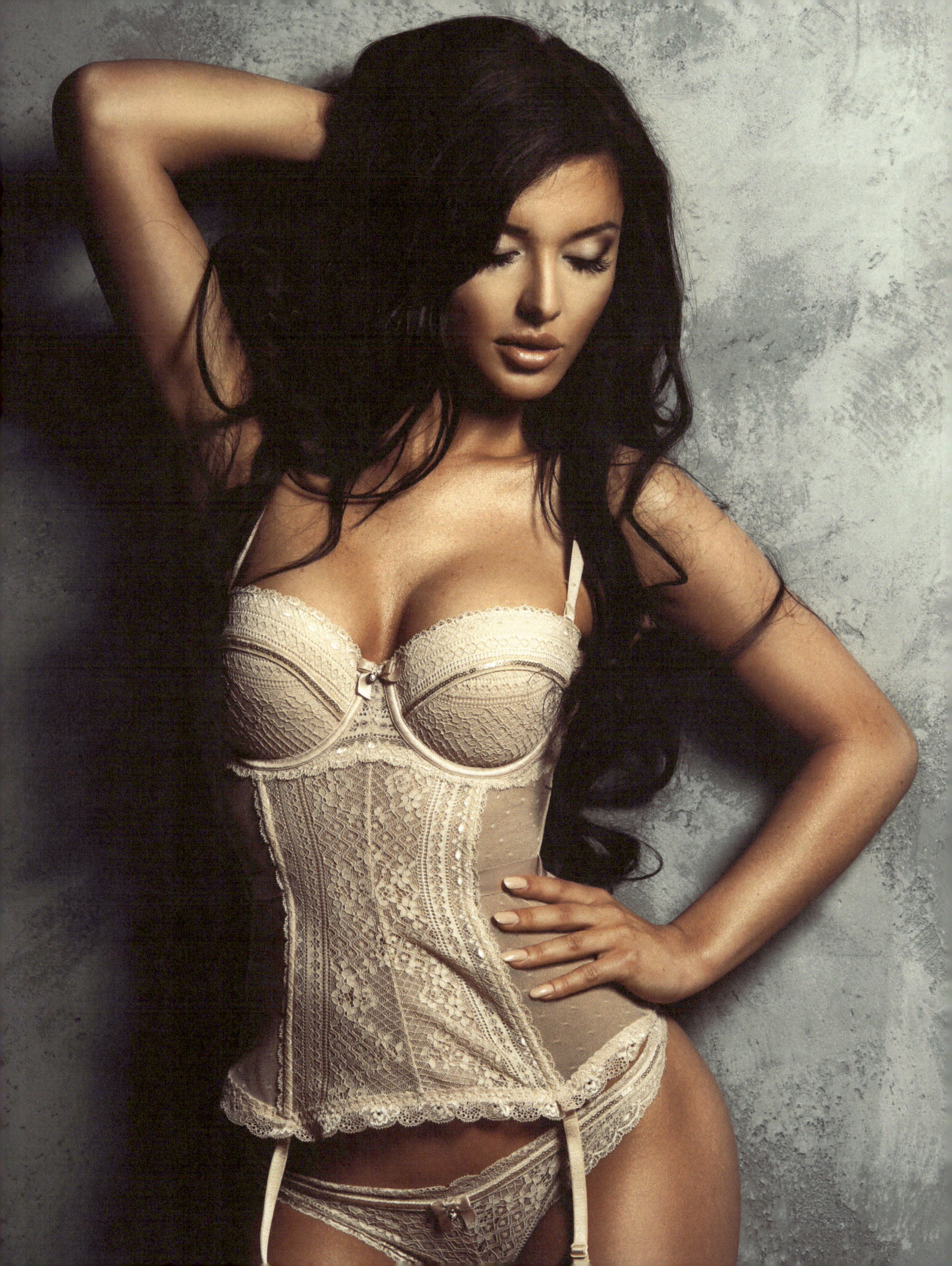

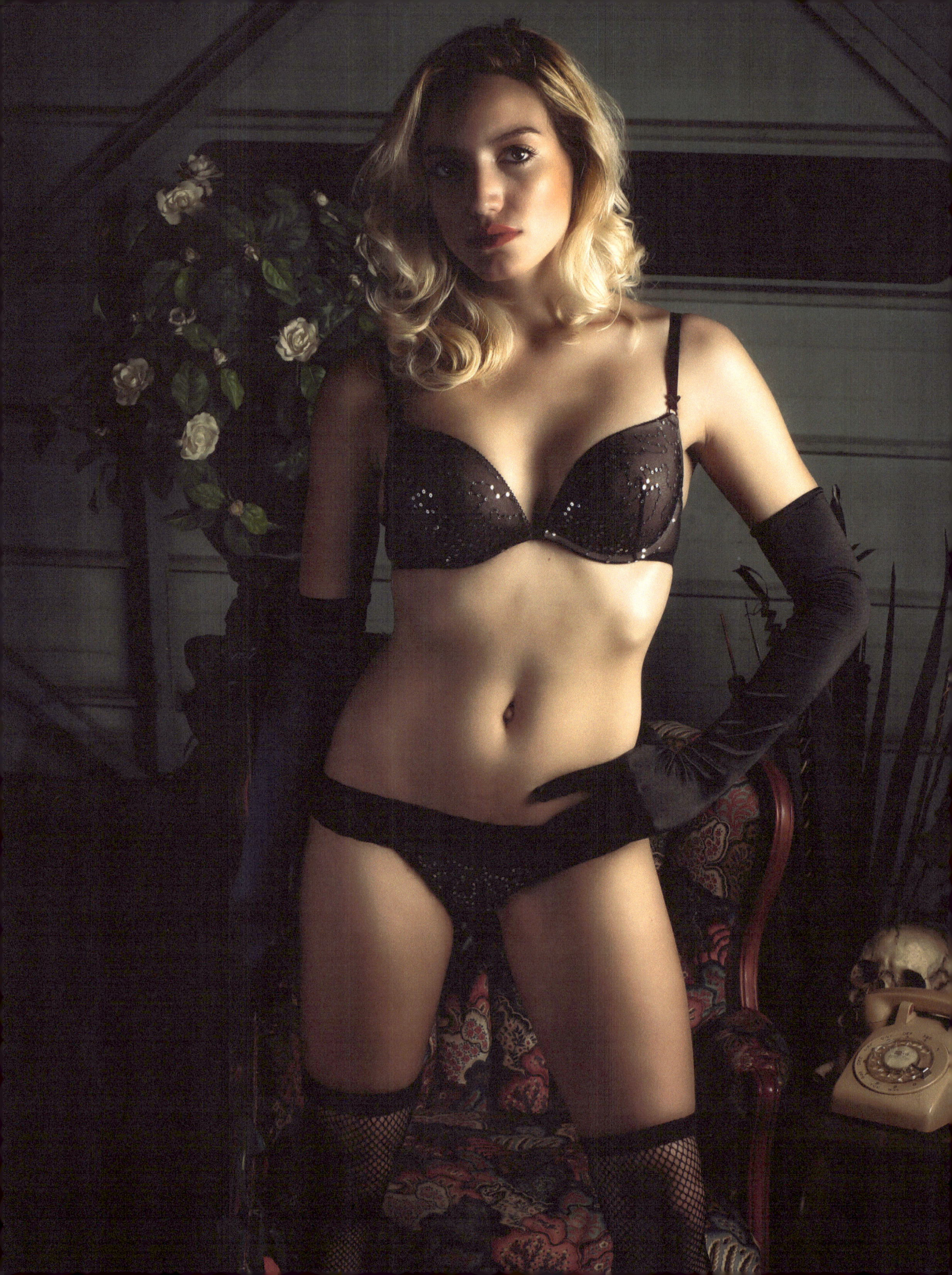

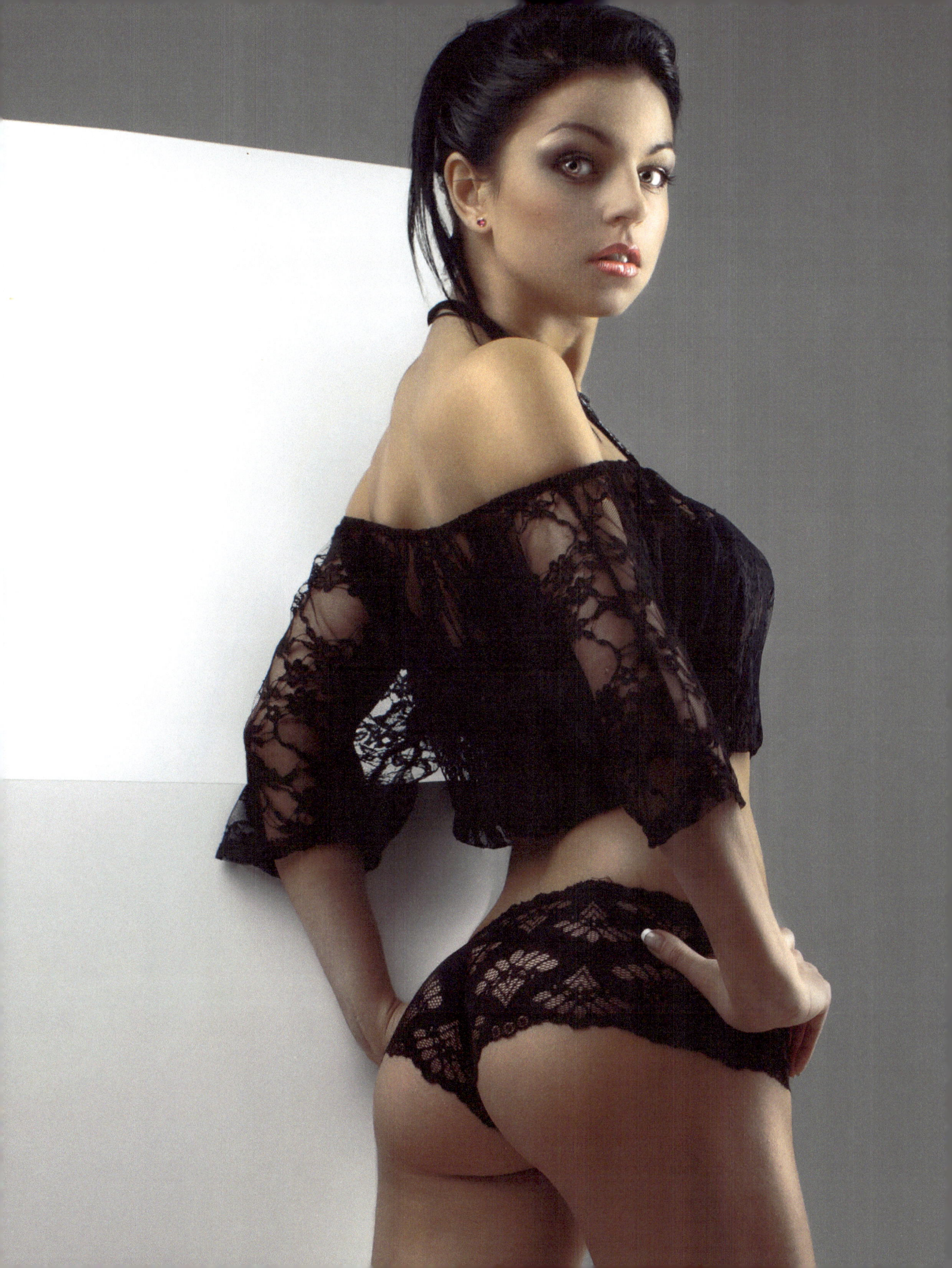

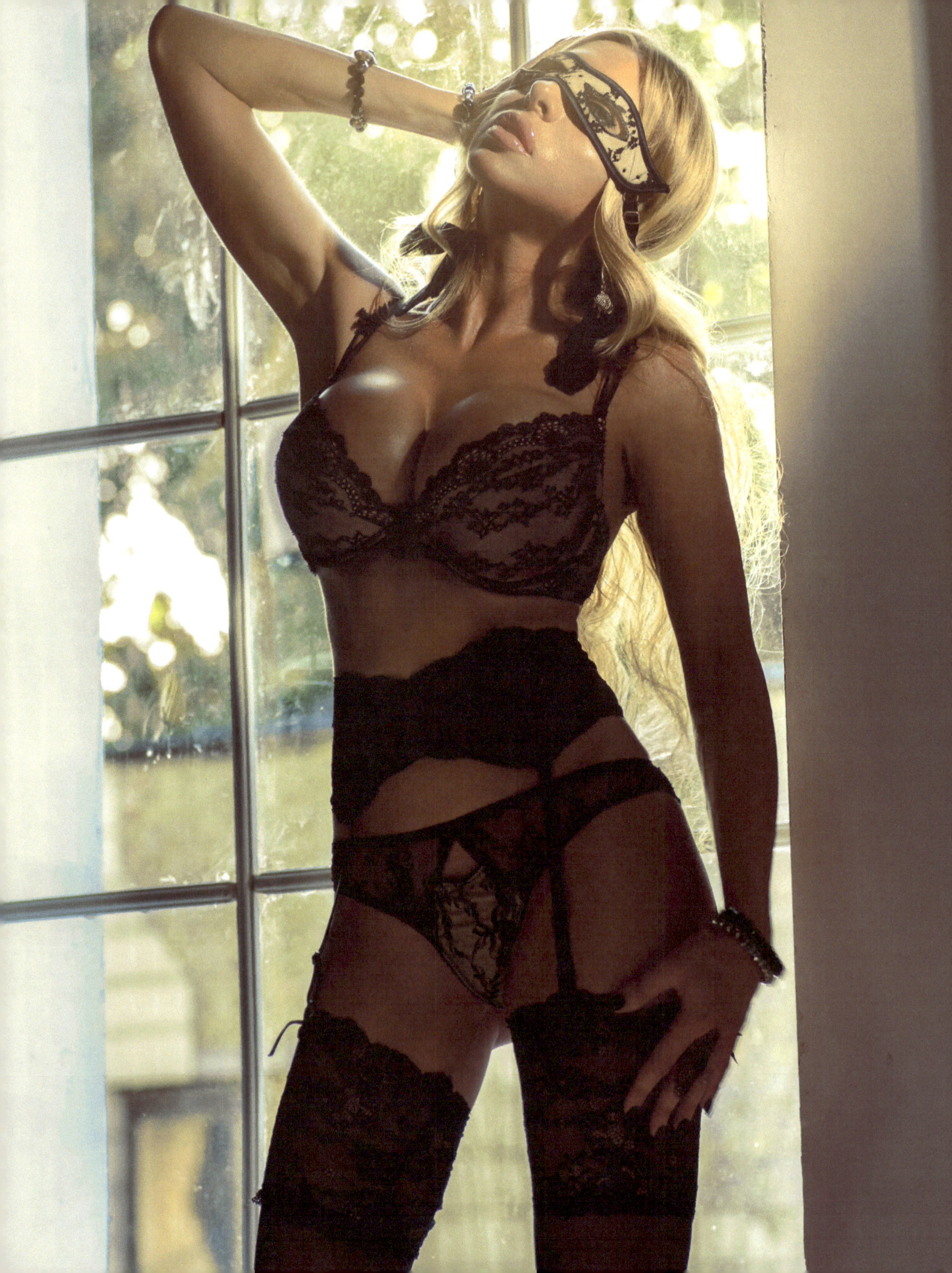

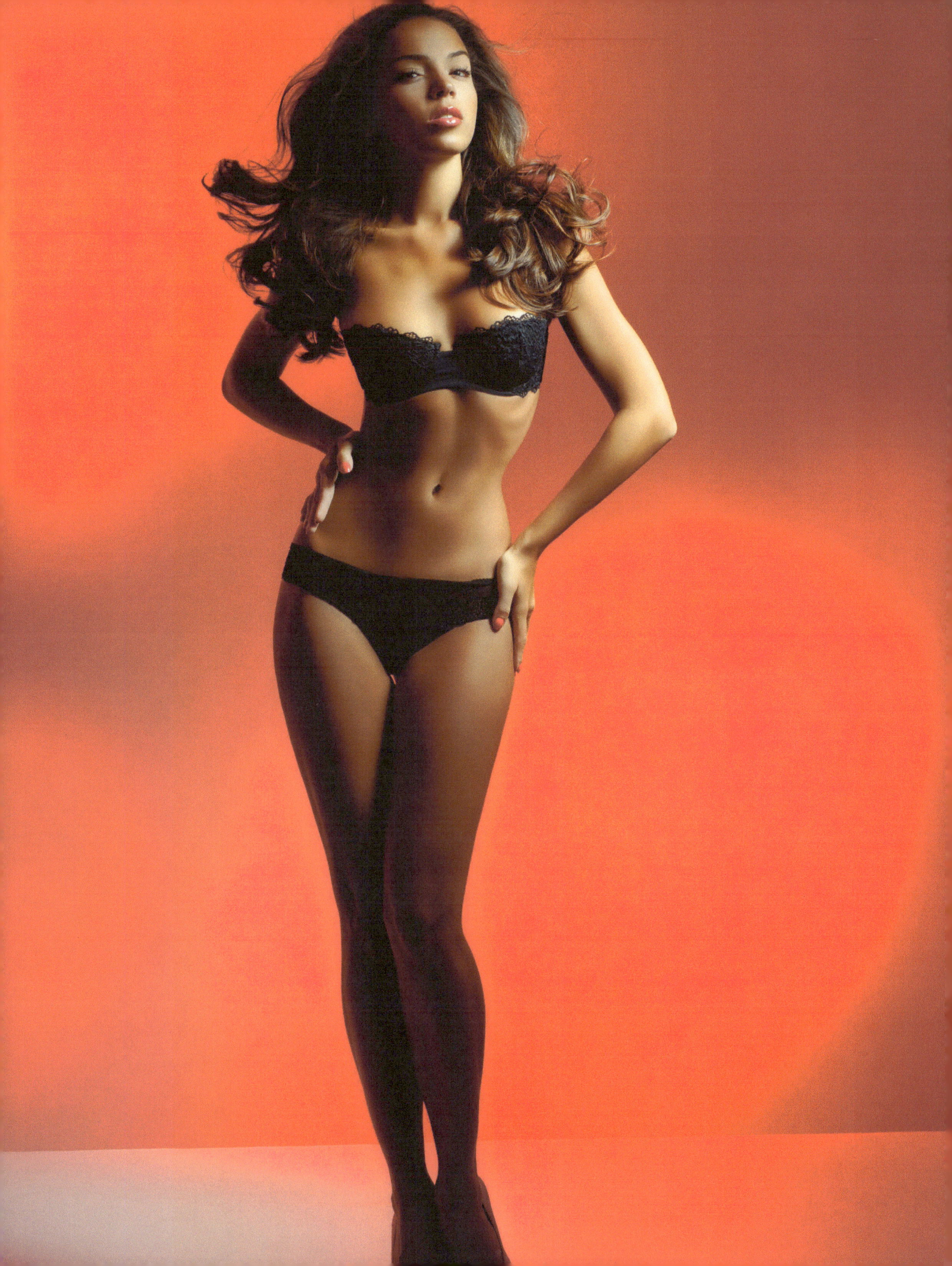

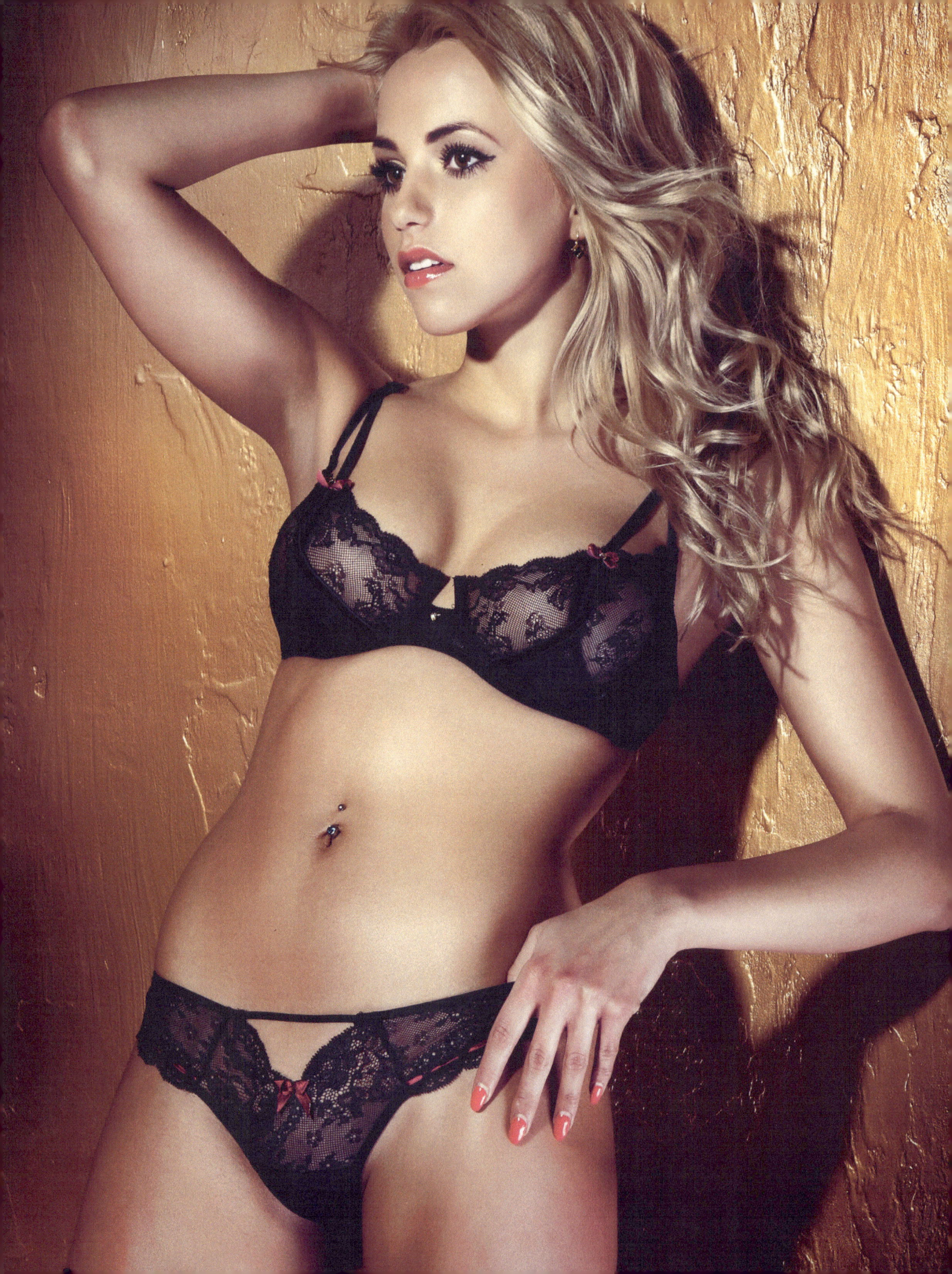

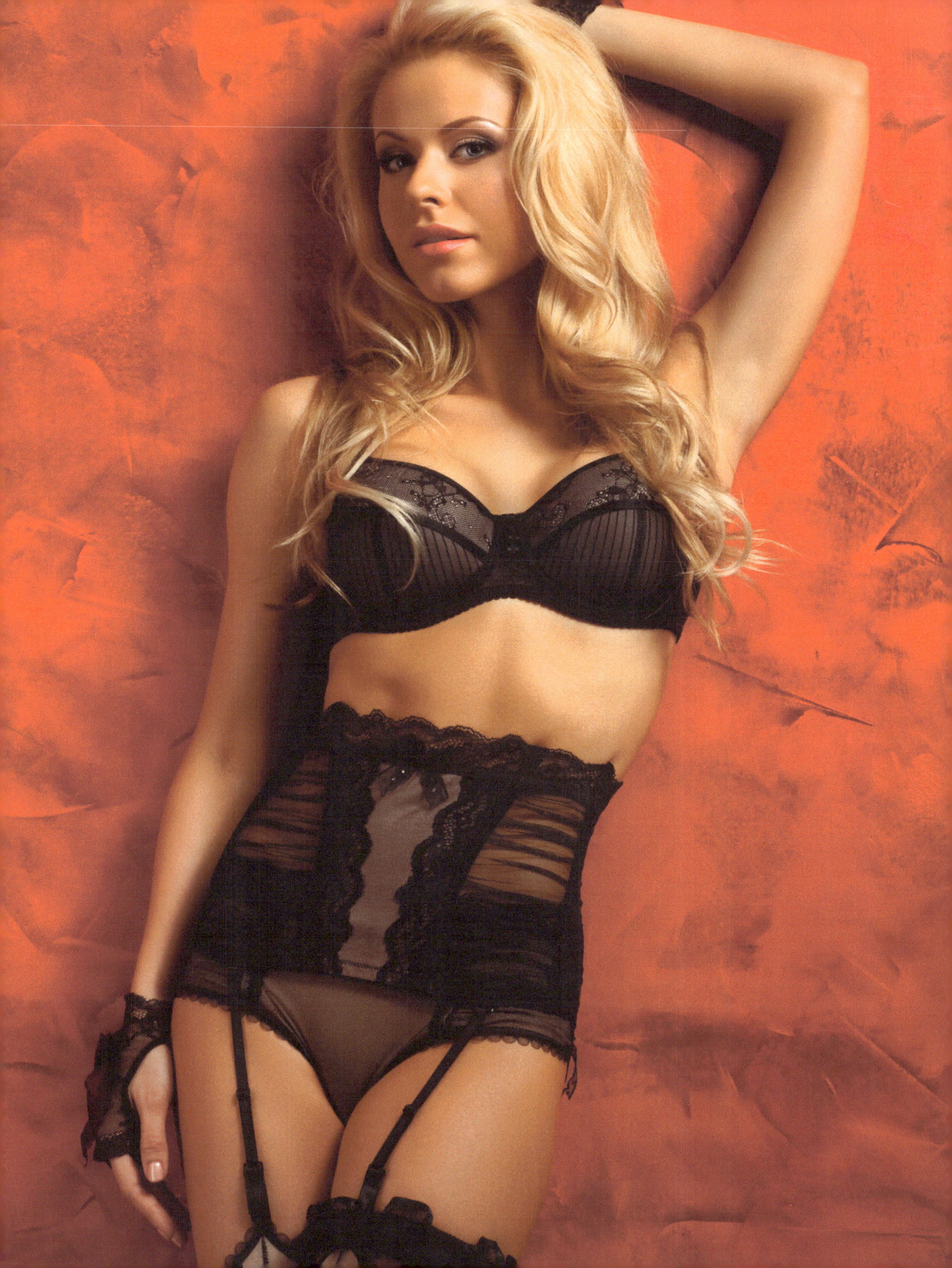

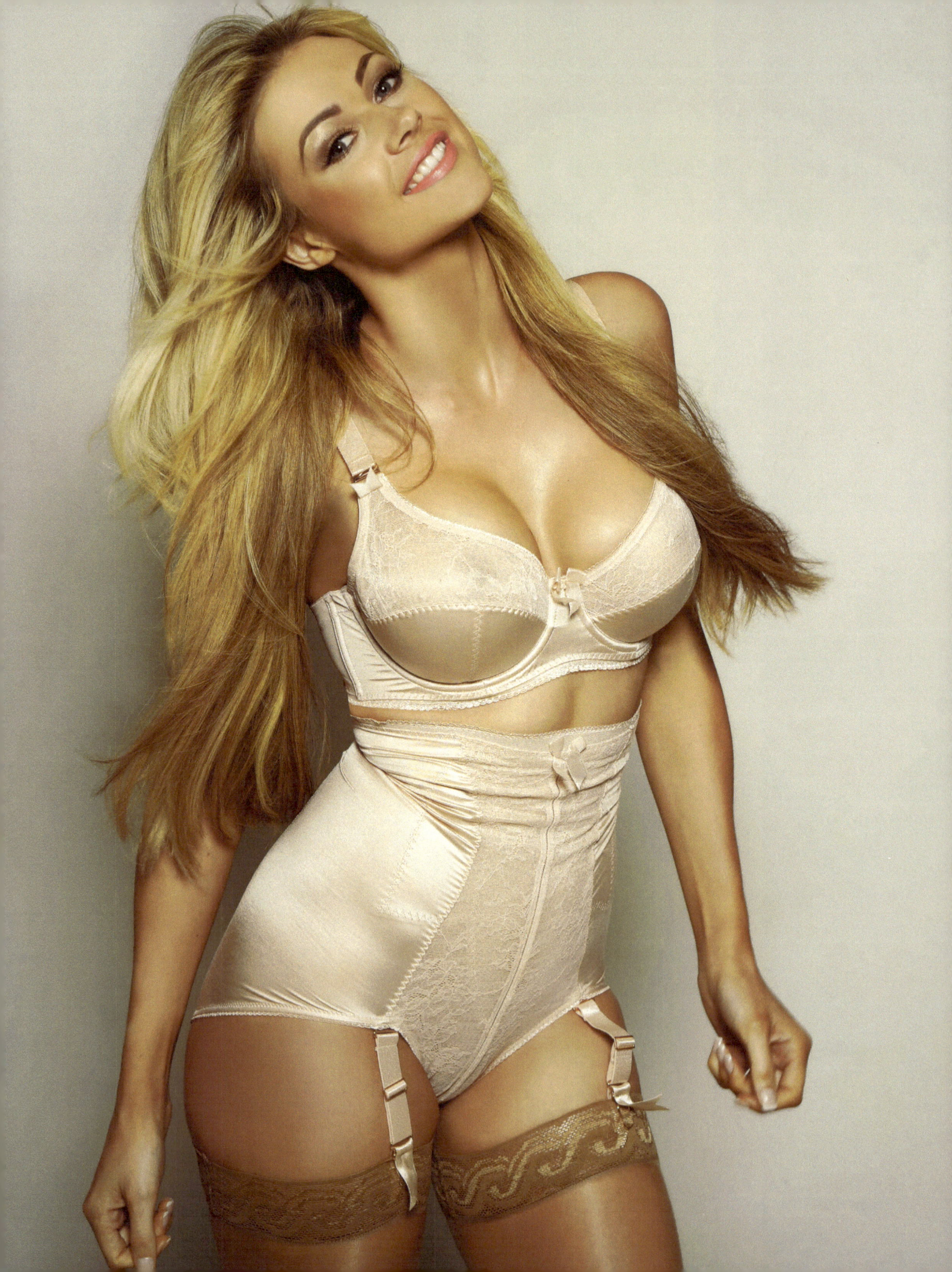

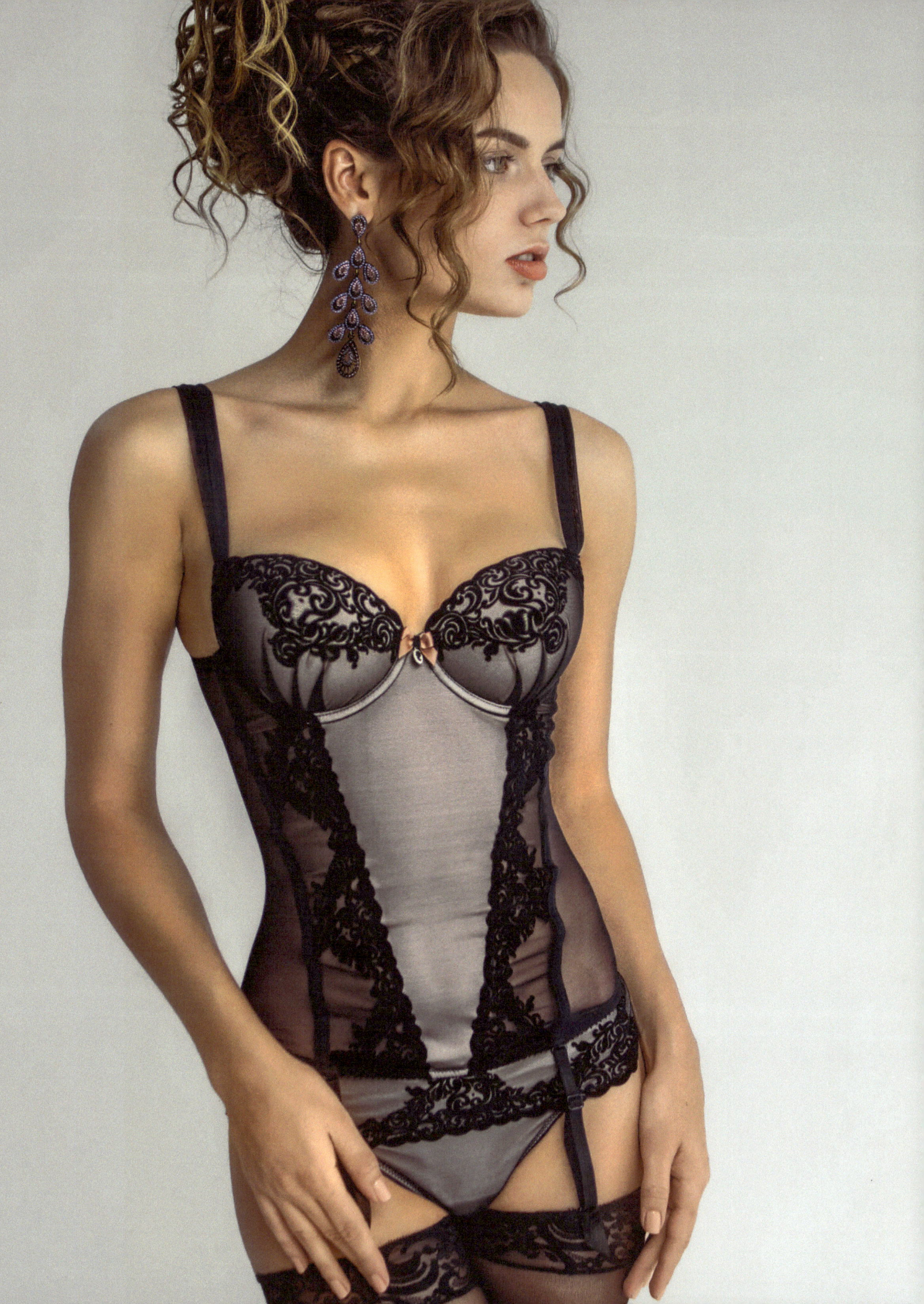

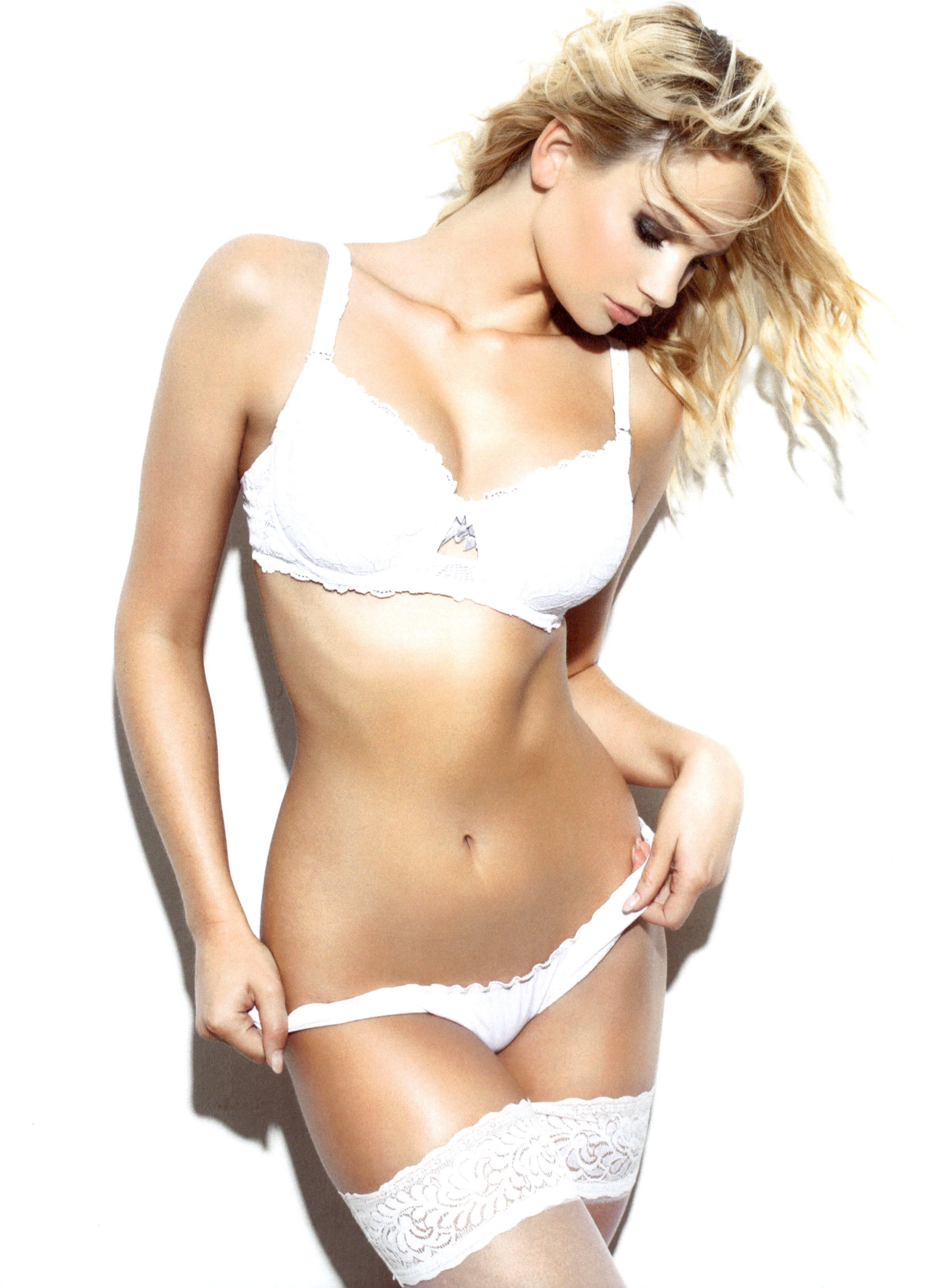

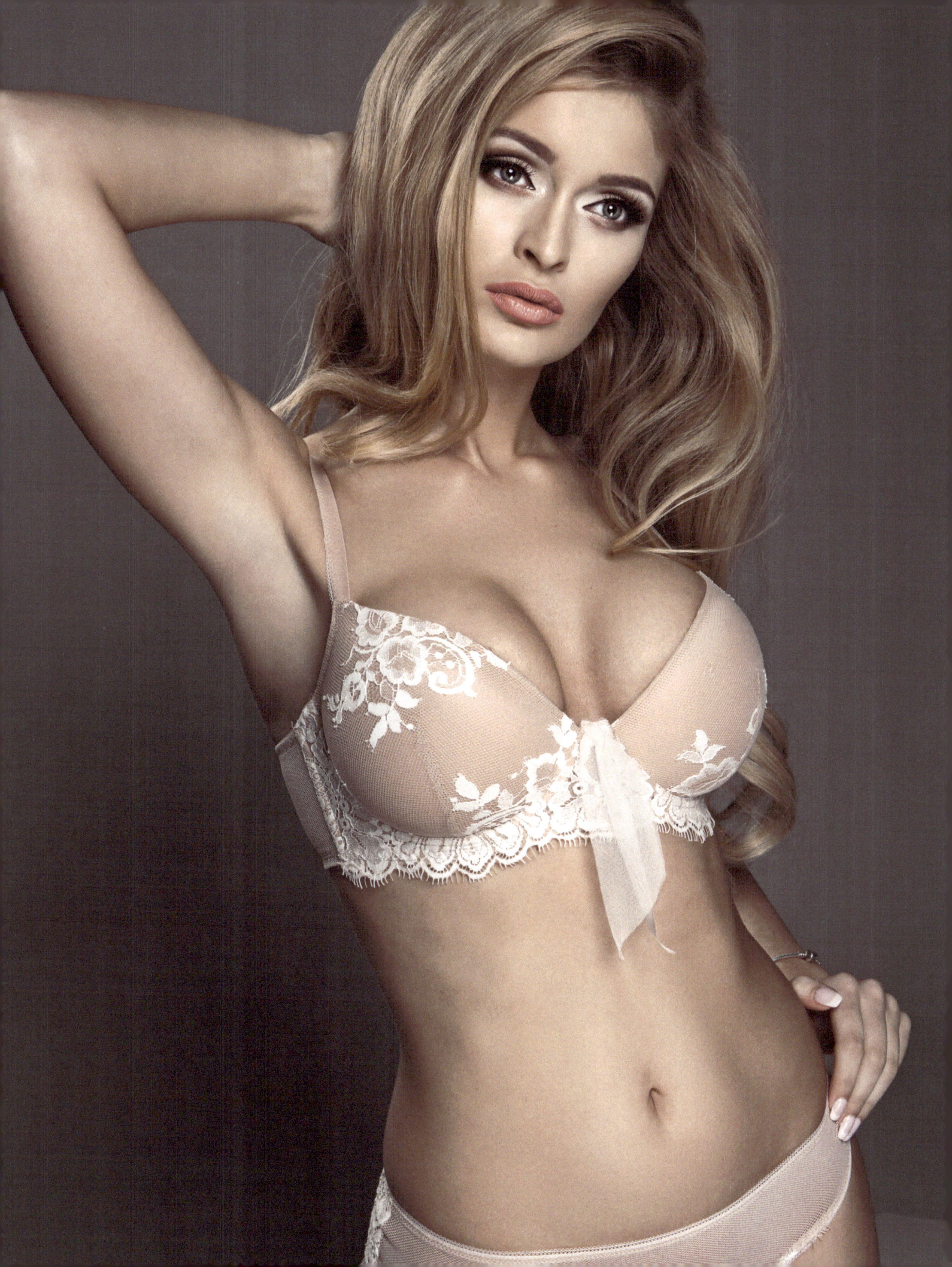

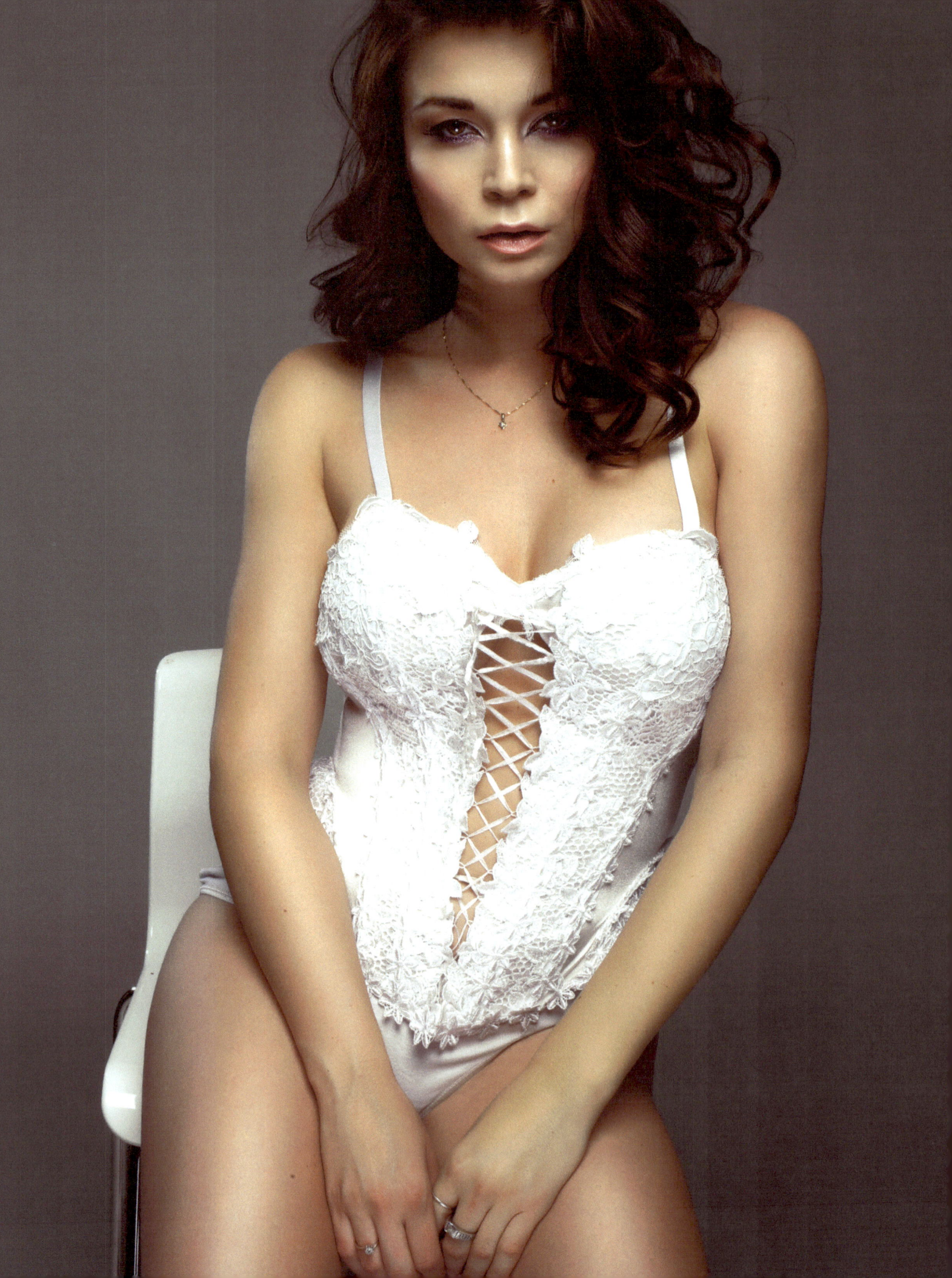

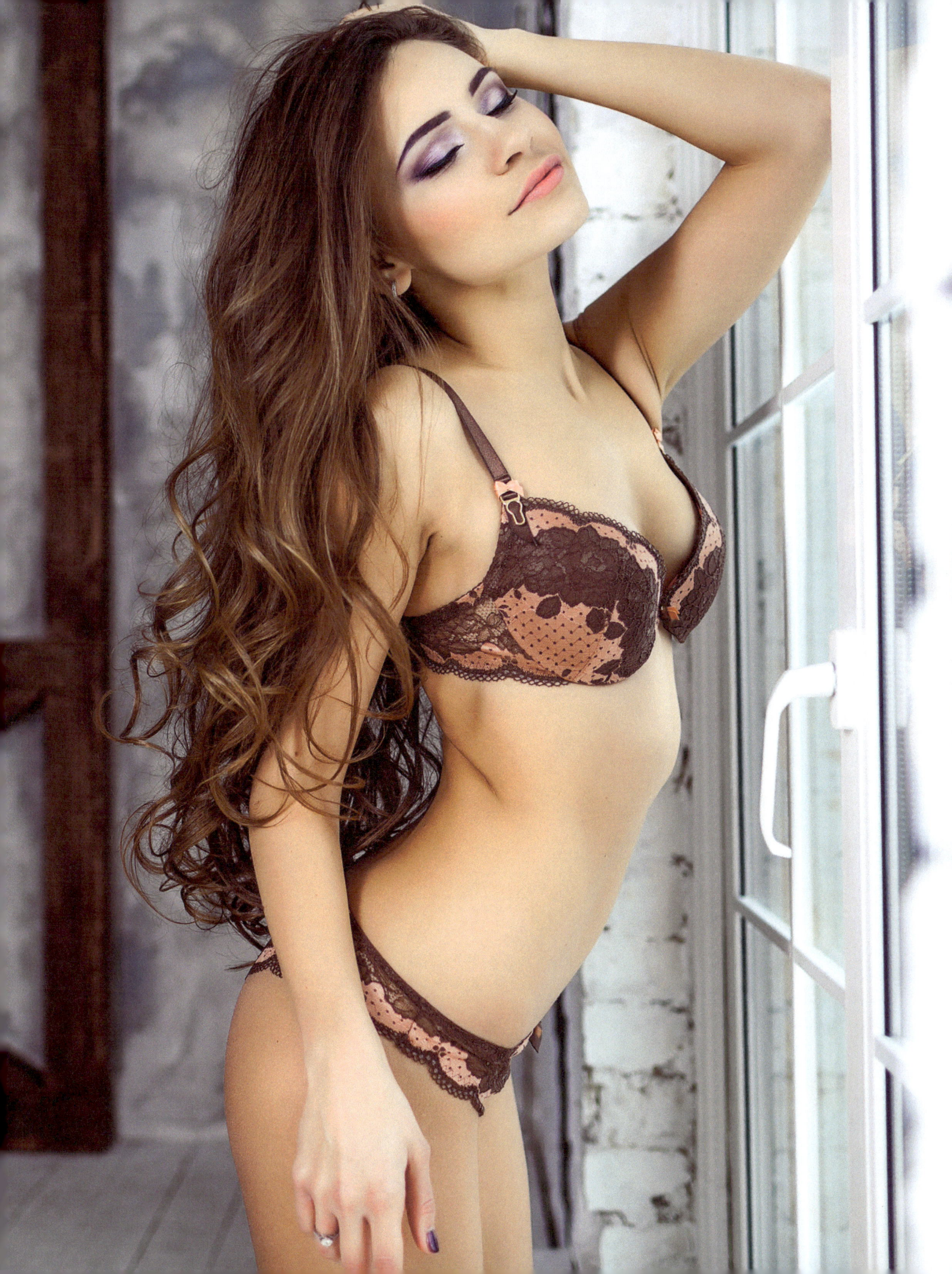

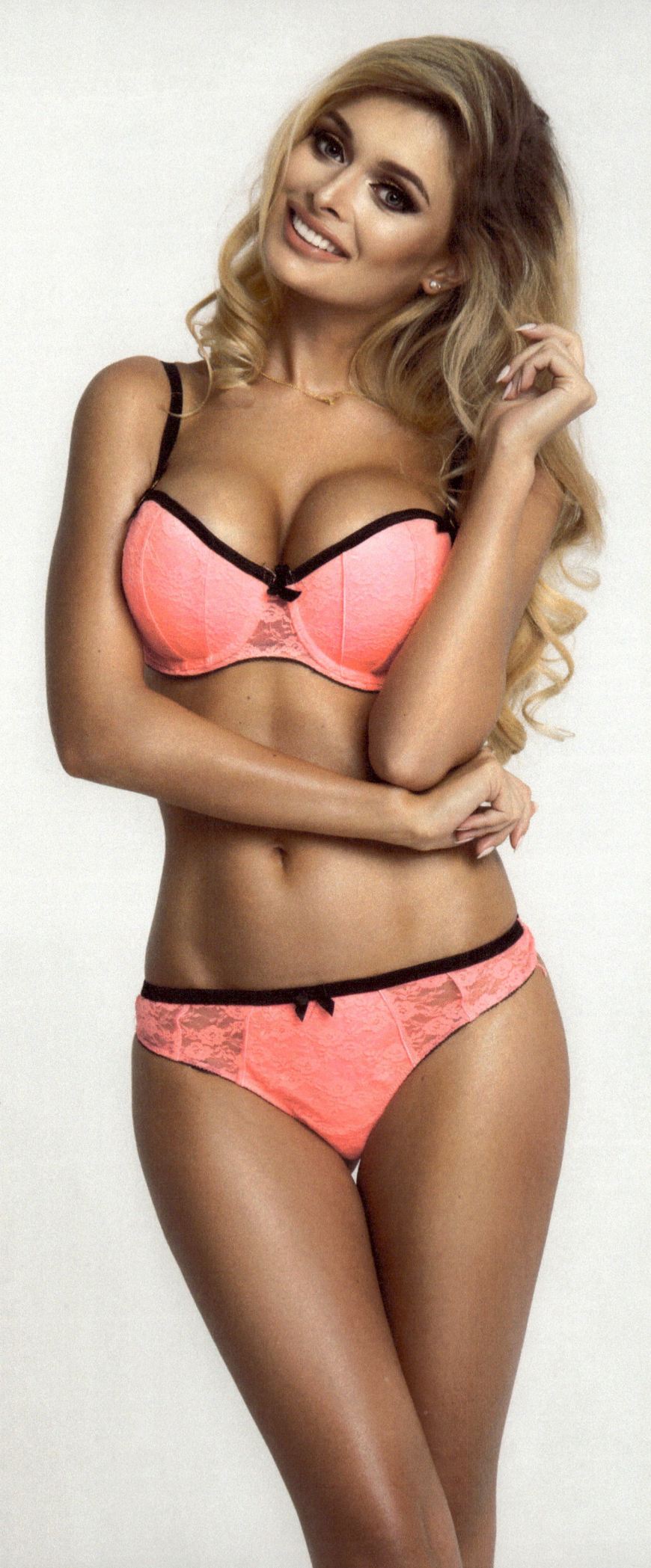

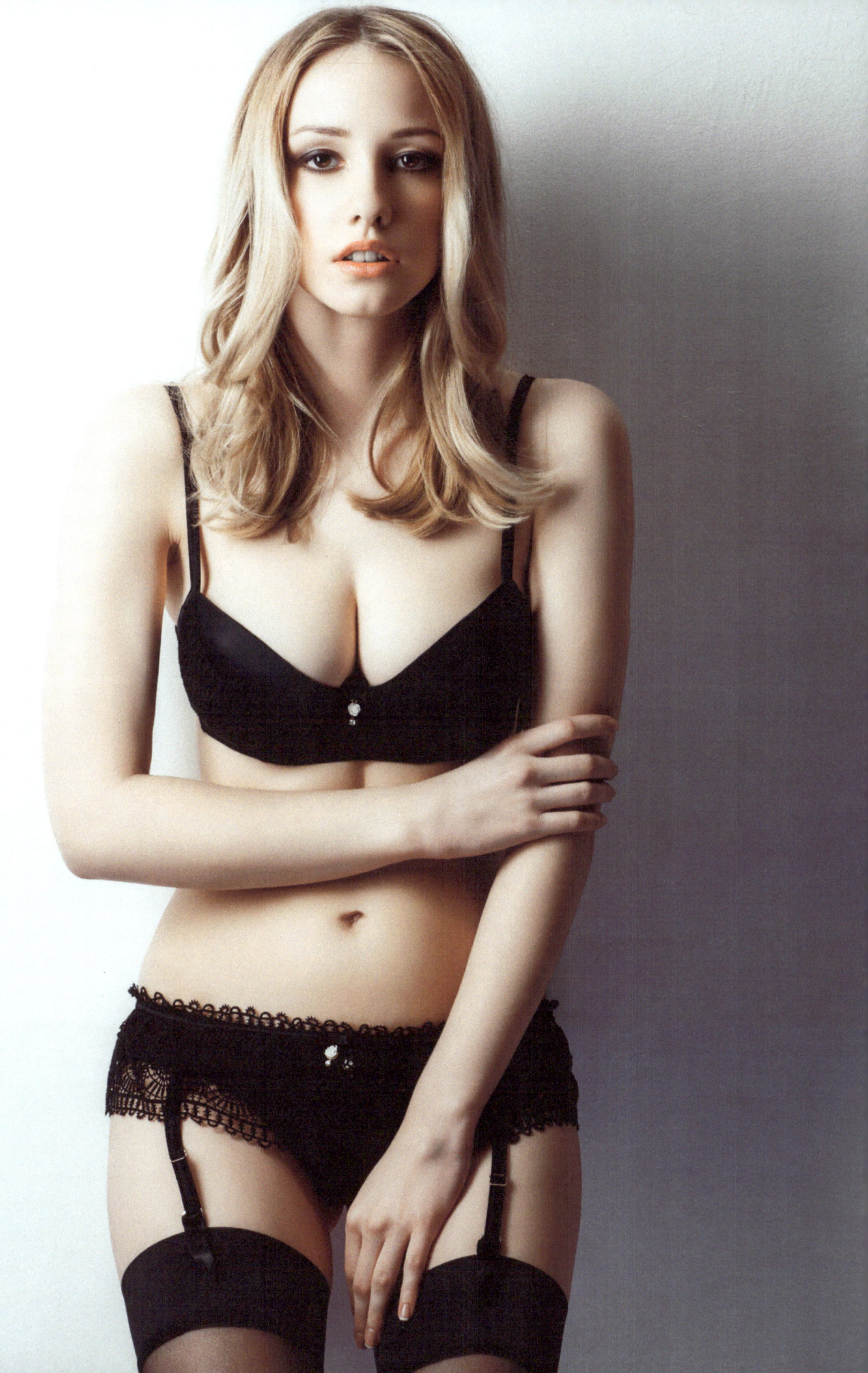

www.ingramcontent.com/pod-product-compliance
Lightning Source LLC
Chambersburg PA
CBHW041305180526
45172CB00003B/983